Behind the Doors
OF SAN MIGUEL
DE ALLENDE

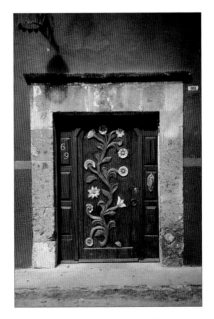

ROBERT DE GAST

Pomegranate
SAN FRANCISCO

For Evelyn Chisolm, always

Published by Pomegranate Communications, Inc.
Box 6099, Rohnert Park, California 94927
www.pomegranate.com

Pomegranate Europe Ltd.
Fullbridge House, Fullbridge
Maldon, Essex CM9 4LE, England

Pomegranate Catalog No. A544

Library of Congress Cataloging-in-Publication Data

de Gast, Robert, 1936–
 Behind the doors of San Miguel de Allende / Robert de Gast.
 p. cm.
 Sequel to The doors of San Miguel de Allende.
 ISBN 0-7649-1341-7 (hb)
 1. Courtyards—Mexico—San Miguel de Allende—Pictorial works. 2. San Miguel de Allende (Mexico)—Buildings, structures, etc.—Pictorial works. I. Title.

 Na2858 .D425 2000
 720'.972'41—dc21 00-035699

Cover design by Harrah Argentine and Poulson/Gluck
Interior design by Poulson/Gluck, Richmond, California

PRINTED IN CHINA

09 08 07 06 05 04 03 02 01 00 10 9 8 7 6 5 4 3 2 1

Behind the Doors

OF SAN MIGUEL
DE ALLENDE

IT IS REMARKABLE THAT A small, dusty hillside town in the middle of Mexico—a town without an airport or a casino, a town more than four hundred miles from the nearest beach—ranked as *Travel and Leisure* readers' sixth favorite city in a March 1998 survey of the "world's best value." A few months later, *Condé Nast Traveler* placed the town in twelfth position among its favorite cities in the world—incredibly, ahead of Vienna, Salzburg, and Hong Kong.

The town is San Miguel de Allende. Well known, even famous, in Mexico, it is hardly a household word in the rest of the world. Located near Mexico's geographic center, two hundred miles north of Mexico City and six hundred miles from the Texas border, San Miguel (as it is customarily shortened) enjoys a nearly flawless climate, with cool summers and moderate winters. In the last quarter-century, this beautiful place has attracted a growing number of North American and European expatriates and tourists.

San Miguel came into existence around 1542, less than two dozen years after the Conquest of Mexico and the founding of New Spain. The

historical records are vague, documentation almost nonexistent. But the bare outline goes like this: Sometime in the early 1540s a Franciscan friar who had taken the name of St. Michael, one of the archangels, came to the area to convert its dominant tribe, the Chichimeca Indians, to Christianity. He established a mission on the banks of the Laja River a few miles from the present site of San Miguel. An early chronicler wrote that "he took possession of the place and built a chapel with branches." This settlement, named San Miguel de las Chichimecas (the first of its many names), is thought to have been destroyed by Indians in 1551. The friar's successor, Fray Bernard Cossin, moved the tiny settlement a few kilometers to the east, up the slope of a hill called Izquinapan. Aside from the difficulty of defending the original settlement, this relocation was no doubt spurred by the unreliable water supply of the Laja, and the discovery of a copious spring (El Chorro, which supplied the town with all its water until the 1970s).

A church was built at the new site, of course. Called La Capilla de la Santa Cruz, it was made of stone, not branches. Nothing remains of its original construction, but a church still stands on the same spot, a stone's throw from the spring. Located on what had become an important route for the transport of silver to Mexico City from the mines of Guanajuato, Zacatecas, and San Luis Potosí, the town grew rapidly. A garrison was established and the settlement became known as San Miguel el Grande. Cloth factories opened, ranching became big business, and tanneries and blacksmithing endeavors flourished. It is said that the serape was invented in San Miguel.

The town became the residence of choice of the region's wealthy landowners. By 1750 it stood out as one of the most important and prosperous settlements in the viceroyalty of New Spain. San Miguel el Grande flourished throughout the eighteenth century. The population hovered at around thirty thousand, making San Miguel one of the largest towns in New Spain. Grand houses were built, churches and schools inaugurated.

San Miguel el Grande was the birthplace of Mexican independence from Spain and was the first town to be freed from Spanish rule. On

September 16, 1810, Father Miguel Hidalgo, the parish priest of the nearby town of Dolores, joined forces with Ignacio Allende, born in San Miguel, who was captain of the local militia. Allende and Hidalgo were captured and executed in 1811. Mexico finally gained its independence from Spain in 1821. Five years later, the town was officially renamed San Miguel de Allende after its great hero.

The turbulent years following the War of Independence effectively ended the economic growth of the town until the last decade of the nineteenth century, when the political stability engendered by the dictatorship of Porfirio Díaz allowed a certain economic recovery. At this time dams and aqueducts were constructed. Thanks to the abundant spring water, orchards of fruit trees flourished, starting a tradition of horticulture and gardening. Crafts developed and excellent master builders, masons, and other tradesmen brought fame to San Miguel at the beginning of the new century. This growth, combined with the resurgence of a few industries such as textiles, infused life into the town after more than half a century of economic deterioration.

San Miguel once again went into a serious decline when the Revolution began in 1910. The Revolutionary War lasted nearly a dozen years; by 1921 it was over, and much had changed in Mexico. But San Miguel de Allende remained a backwater town for another thirty years.

In 1926 the Mexican government declared San Miguel de Allende a "Historic and Protected Town," and established architectural guidelines restricting changes in exteriors and the building of new structures. As a result, the town has kept its distinctive charm to this day.

San Miguel had always been an especially pretty town, and in the late 1940s it began to attract many artists. It seemed inevitable that a fine arts school would be founded. In the late 1940s, both Bellas Artes and the Instituto Allende were established, the latter under the directorship of Stirling Dickinson, an artist and writer who was, in 1938, the first American to settle in San Miguel. When the U.S. Veterans Administration allowed students to study in foreign countries under the GI Bill, enrollment at these art schools soared, and San Miguel began its meteoric

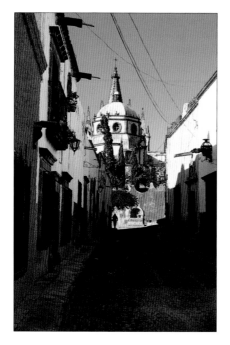

rise to its current status as one of Mexico's cultural hotspots.

Artists and writers flocked to San Miguel. Hotels, restaurants, and shops began to cater to the increasing number of visitors. The economic boom of San Miguel began again. As Mexico's population doubled (from fifty million in 1970 to one hundred million in 1999) so did San Miguel's, from thirty thousand to sixty thousand. Although their number has grown tremendously in the last two decades, foreigners account for only about 5 percent of the total population.

Sprawl has come to San Miguel, but the historic center of the town, with its wonderful collection of Spanish colonial architecture, remains unspoiled; the town still feels like a picturesque village. There are more than a hundred restaurants and nearly four dozen hotels and B&Bs, but there are no traffic lights, no parking meters, no fast-food franchises. Walking is the best way to move around San Miguel—but while walking the cobblestone streets is a pleasant way to admire the great variety and beauty of the town's doors, it gives no hint of what can be seen behind these doors.

The plan of San Miguel's historic center is basically a grid, a design favored by the Spaniards after its introduction from North Africa by the Moors. San Miguel was built on a hill, and the terrain made a precise grid pattern untenable: as a result, no street is exactly straight. This, of course, lends charm to the urban scene. The streets are lined by colorful, variously painted, continuous walls of one-story or occasionally two-story houses. The roofs are invariably flat. Massive horizontal timbers are

embedded in parapeted masonry walls to support an extremely heavy roof of earth or mortar. Cylindrical rainspouts project through the parapet along the walls to provide drainage—often upon an unwary pedestrian. Interestingly, the flat roof, another idea brought into Spain by the Moors, was well established in Mexico when the Spaniards arrived.

The streets and alleys of San Miguel are lined not with trees, but with walls. The street itself is just a corridor between houses that present an inscrutable walled façade. A large portal with a pair of massive doors wide enough to admit a carriage provides access to the world within; these doors, unanimously acclaimed by visitors for their beauty, are the only sign of the space that lies behind the walls. As Antonio Haas notes in *Gardens of Mexico,* "Mexican gardens are always behind walls. The Hispanic-Moorish tradition of privacy in the garden still prevails. . . . The generous Anglo-Saxon tradition of open plantings visible to all . . . is utterly alien to the Mexican."

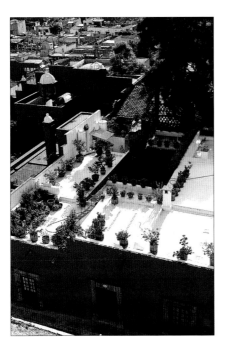

Although each building has an entrance door, many have no windows—or just the occasional window, masked by decorative grillwork. The photographer Tim Street-Porter writes that "the typical colonial house was a town house, and in many ways it was not so different from the houses of pre-Hispanic Mexico. These houses were inward-looking, presenting blank faces, and around them were walled gardens."

The residents find their privacy behind these walls. "The Mexican wall," marveled Tony Cohan in *Mexicolor*, "is an enigma. It keeps things out

(people, animals, dust, floodwater) and in (secrets, possessions, people, animals). . . . It separates while uniting. The wall is like clothing—a layer or barrier demarcating private and public space. The urge to see behind, over, or through it creates mystery and interest."

In contrast to this impersonal exterior, the inner courtyard was, and still is, a vivid microcosm of Mexican life.

"There is always the patio," noted American writer Charles Macomb Flandrau in his book *Viva Mexico* more than one hundred years ago. "They are of all sizes, of all degrees of misery and splendor and of most shapes. . . . but in the meanest of them there is an expressed yearning for color and adornment that, even when ill cared for and squalid, has been at least expressed. It takes the form, most fortunately, of flowers, with often a fountain in a circular basin of blue and white tiles. A Mexican patio, in fact, is considerably more than a courtyard. It is a flower garden surrounded by a house."

The word *patio* comes from the Latin *patere*, "to be or lie open." The patio is an inner court or enclosed space open to the sky. (The *Encyclopedia Britannica* says, archly, "The term patio is also commonly used in the United States, incorrectly, to describe any small, semi-enclosed residential terrace.") The well-known Mexican designer Patricia O'Gorman calls the patio "the heart of all Spanish colonial architecture." Usually, the courtyard space within the dwelling is entered through a *zaguán,* a hallway or covered passageway through the house that serves as a transitional space leading onto the patio.

Patios, in lieu of garages, have been able to accommodate cars, and as one architectural critic has pointed out, "so continues the tradition of the courtyard being a multi-purpose space that responds to the lifestyle of its occupants." The patio is almost always paved and boasts a fountain, usually in the center. Charles Macomb Flandrau remarked upon "the perpetual fascination of their flower-filled patios of which the passer-by gets tantalizing glimpses through open doorways." That fascination has not abated. Every Sunday for the past forty years the Biblioteca Pública, a mostly volunteer organization in San Miguel, has sponsored a House and Garden

Tour that continues to be one of the most popular activities for visitors.

The Historic District's three dozen or so blocks occupy less than a square mile and can easily be circumnavigated on foot in an hour. There are probably two thousand doors, two thousand entrances, two thousand open spaces behind the doors that cannot be seen from the street. Perhaps half of those spaces are occupied by commercial ventures: stores, restaurants, galleries, workshops, hotels. There are schools and offices. Since there is no zoning, there is little or no stratification; each block offers a fascinating variety of homes and businesses. The house of a wealthy Canadian retiree may be next to a tiny grocery store. A school adjoins a bakery. A pharmacy is squeezed between two artists' studios. Walking around one typical block, you'd pass by a religious bookstore, a medical clinic for the indigent, a church, a tourist office, a terrace-type café, a baby supply store, a shop that sells only crucifixes, a lumberyard (!), a barbershop, an elementary school, a shop that sells bus tickets, an upscale fashion shop, a neighborhood café, residences, a hotel and restaurant, a furniture store, an antique store, yet another restaurant, the town's public lavatories, and another church.

Finding and photographing the exterior spaces behind the doors was no simple enterprise. It was clearly impossible to knock on every door and request permission to take a look (or a picture), and so I relied on the

help of friends, neighbors, and realtors to find interesting spaces. A walk through the streets in the early morning would occasionally yield a glimpse into a courtyard through an open door, as a maid scrubbed the stoop or the milk truck stopped to deliver its wares. But several of the spaces I photographed are public: too beautiful or interesting to omit. The courtyard of Bellas Artes, for example, though open to the public, is often missed by the casual visitor.

I was rarely refused permission to make photographs. Generally, indeed, people were pleased and proud to have their patios and gardens photographed.

Instead of captioning the photographs with the names of the owners (or renters) of the properties, I decided to use only street addresses. Things can change quickly in San Miguel. One space (a glass-covered courtyard) I photographed when it was the political headquarters for the governor of Guanajuato became a grocery store a few months later.

Street numbers, on the other hand, are not all that meaningful. Finding a particular house number in San Miguel can be a very frustrating experience. Walking down one block on a street in the *centro* called Umarán, I noted this sequence of house numbers: 164, 11, 10, 124, 22, 21, 122, 113, 20, 18, 98, 96, 108, 102, 8, 100. Street names, too, can be confusing, for the appellation can change every block. For example, a

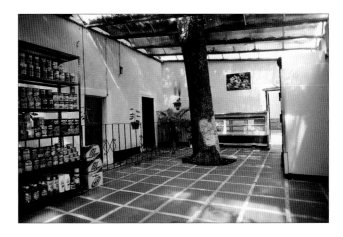

street called Chorro becomes Barranca after two blocks, turns into Murillo for one block, becomes Nuñez for three blocks, and ends up as the Calzada de la Presa before turning into Calle Obraje as the (nearly) straight road exits the town and fizzles out into the *campo*. In the middle of town, to give another example, the street called Garita turns without warning into Hospicio, then Cuadrante, then Pila Seca. The doors and walls can also be misleading. A slightly decrepit-looking wall may hide a first-rate eighteenth-century courtyard, and a dilapidated door may be the entrance to the sybaritic retreat of a European theater director. A handsome, freshly painted wall may hide an abandoned property, home only to some pigs and chickens.

The selection of photographs shown here represents the enormous variety of subjects that can be found behind the walls of San Miguel, in the spaces that are usually inaccessible to the casual visitor. I've been privileged to discover and photograph many, but I also know that many, so many, will forever remain hidden.

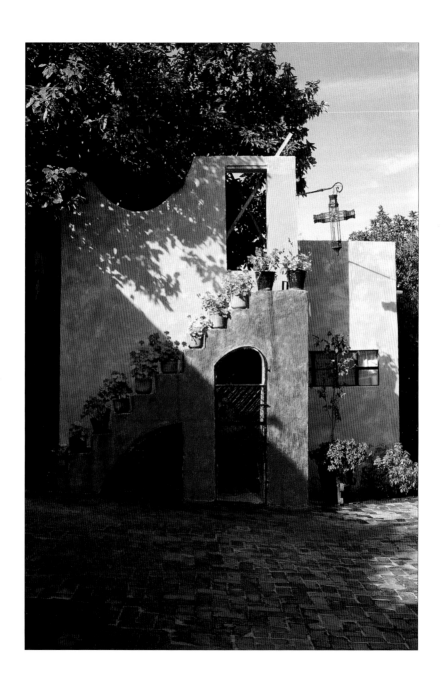

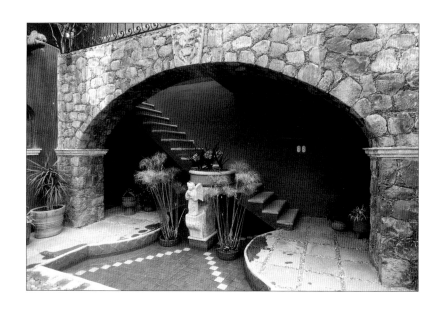

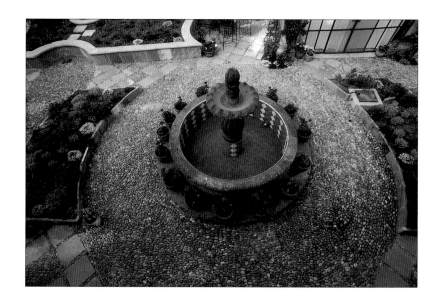

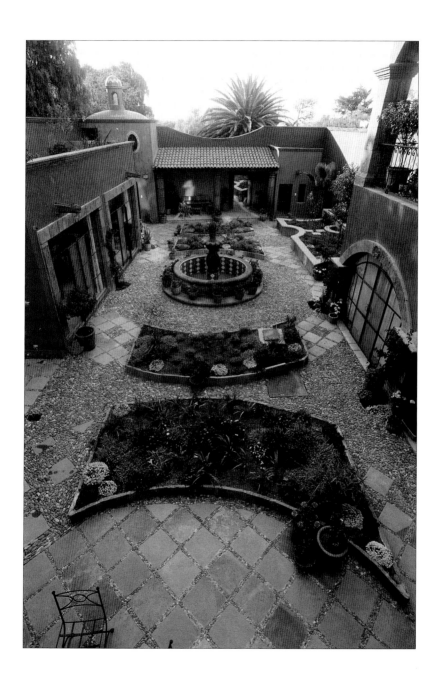

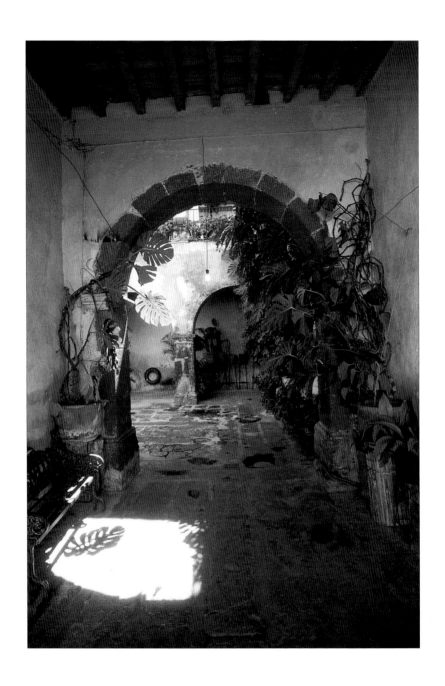

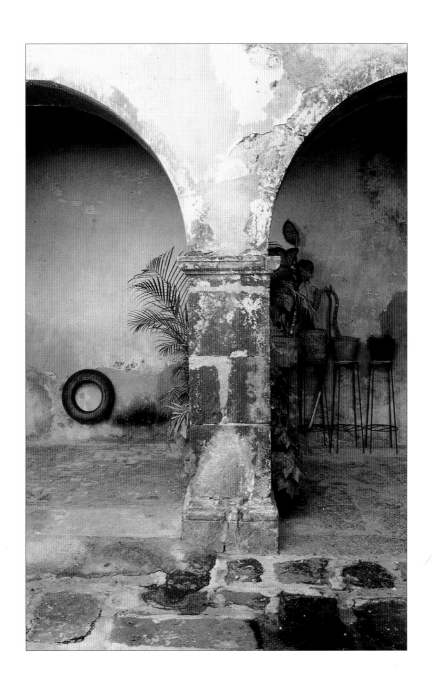

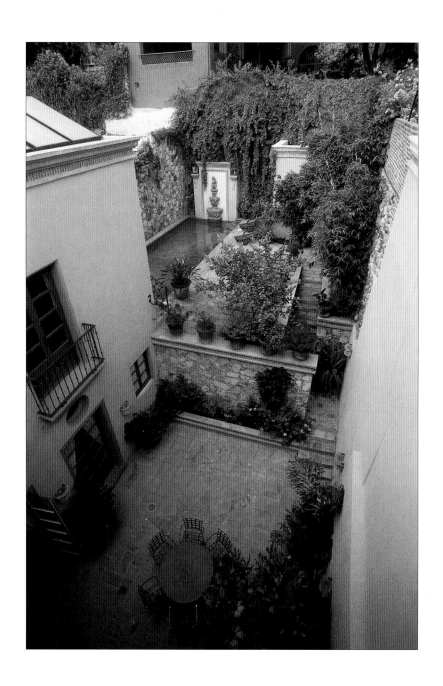

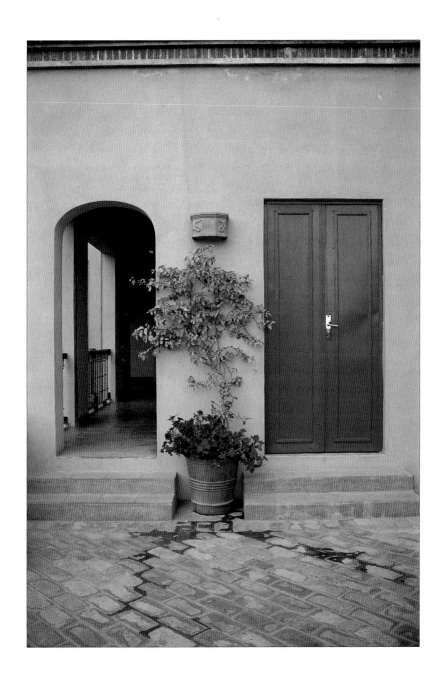

ALDAMA 22

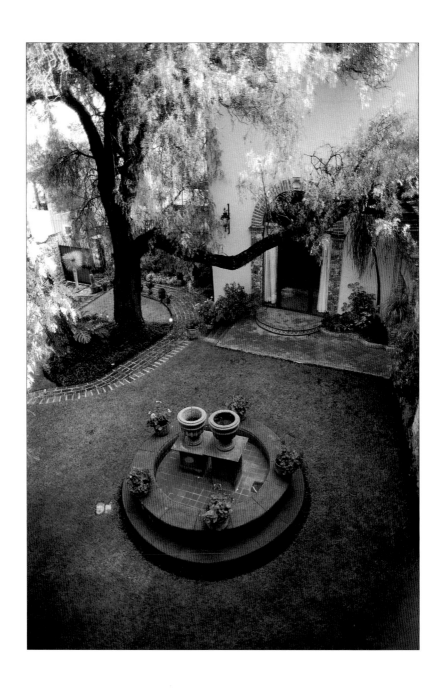

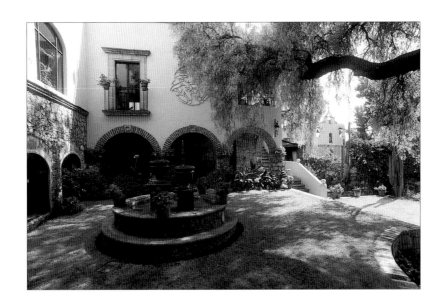

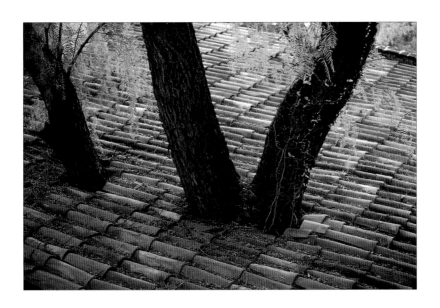

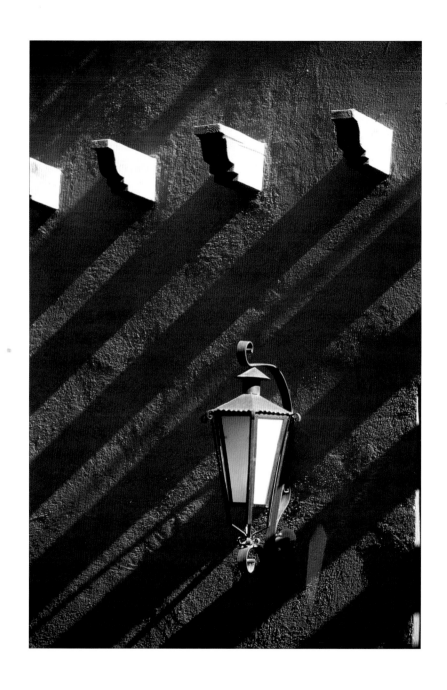

CALLEJÓN VOLANTEROS 1B

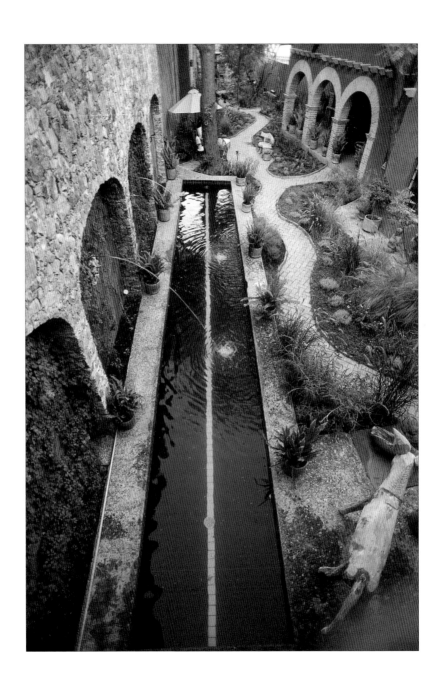

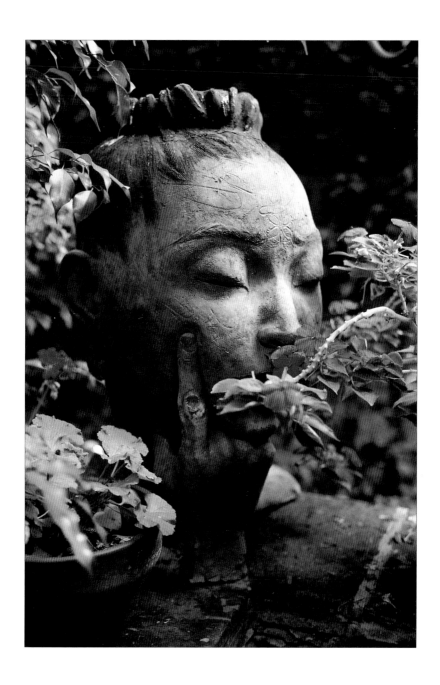

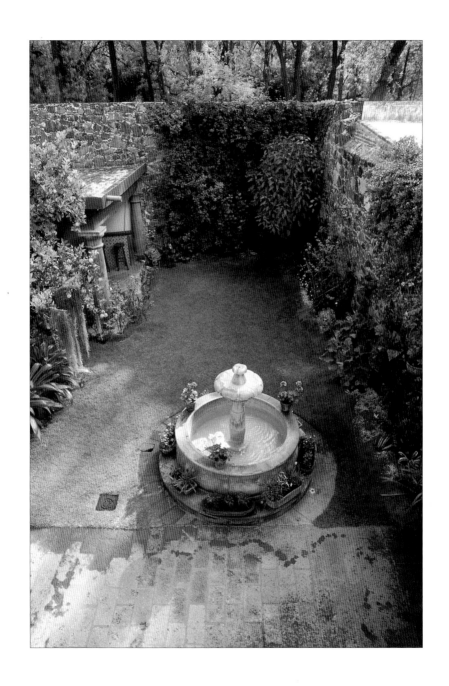

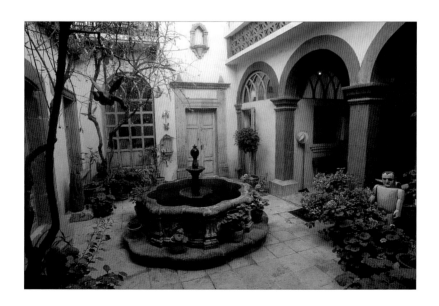

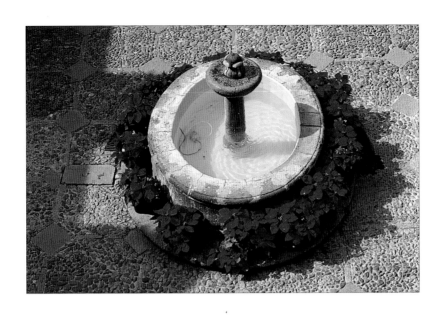

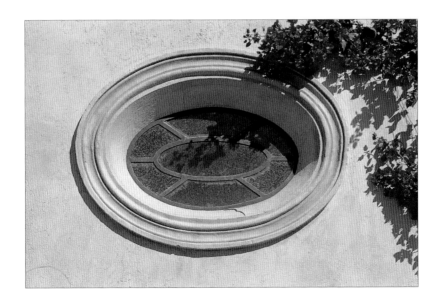

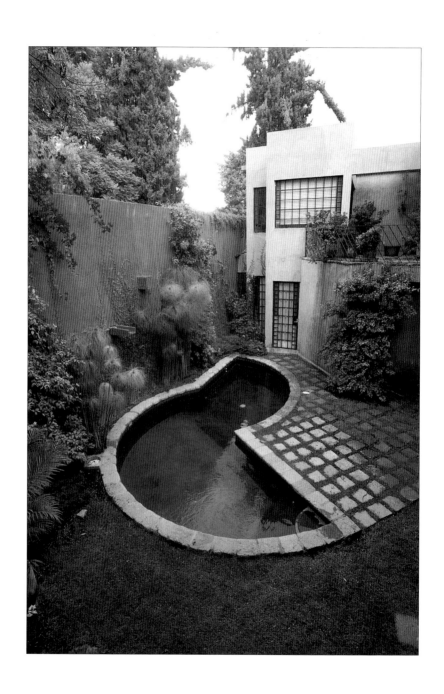

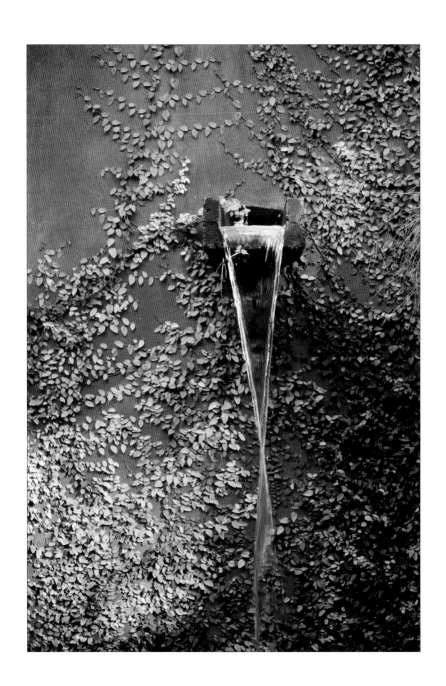

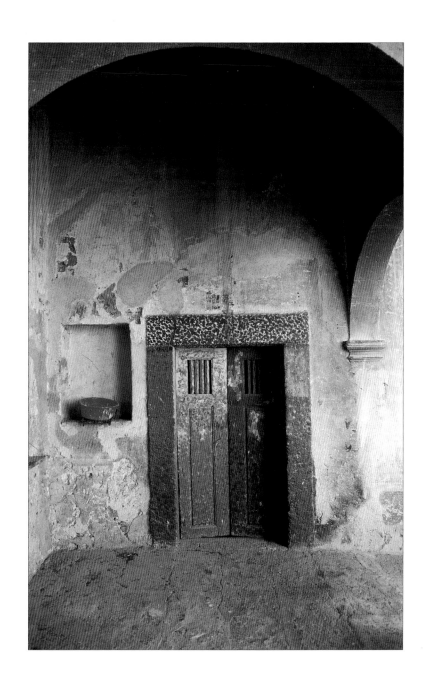

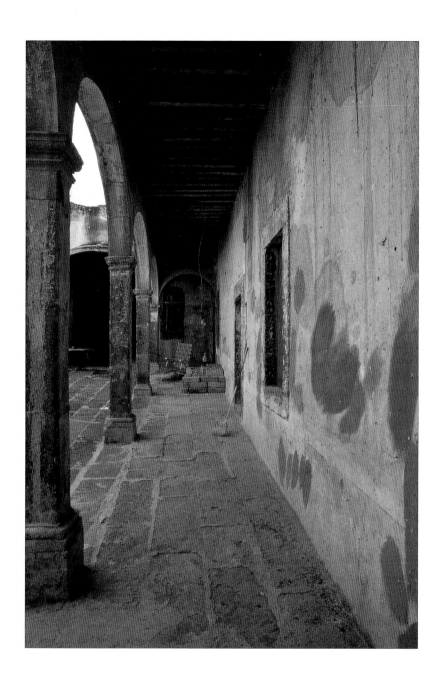

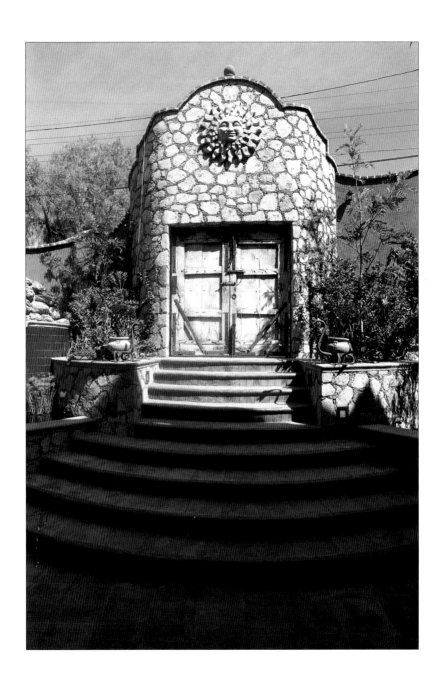

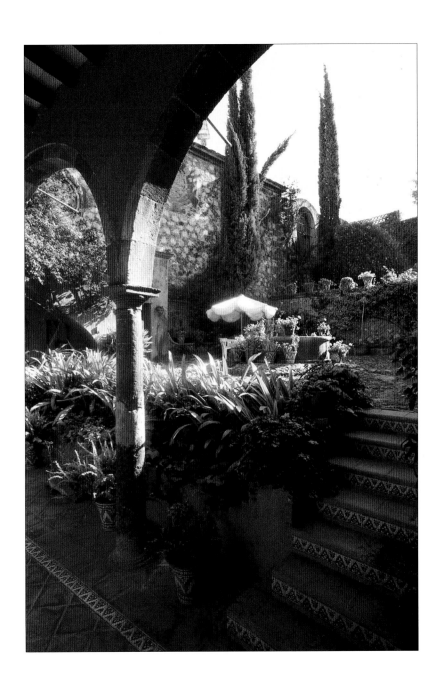

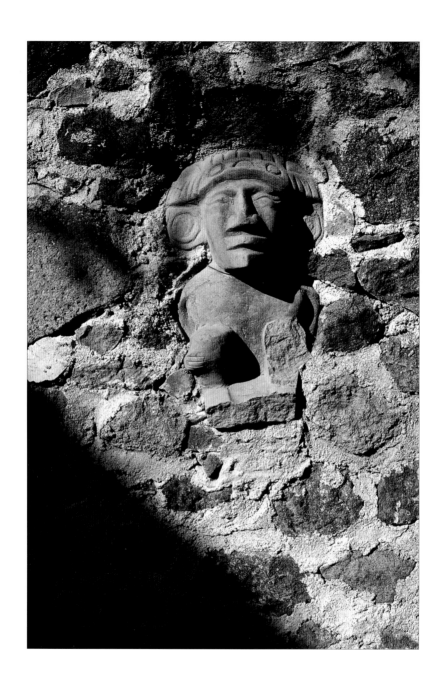

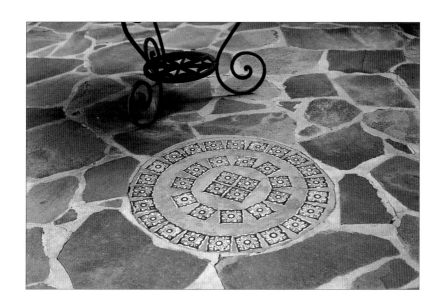

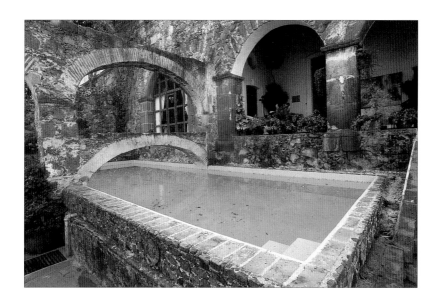

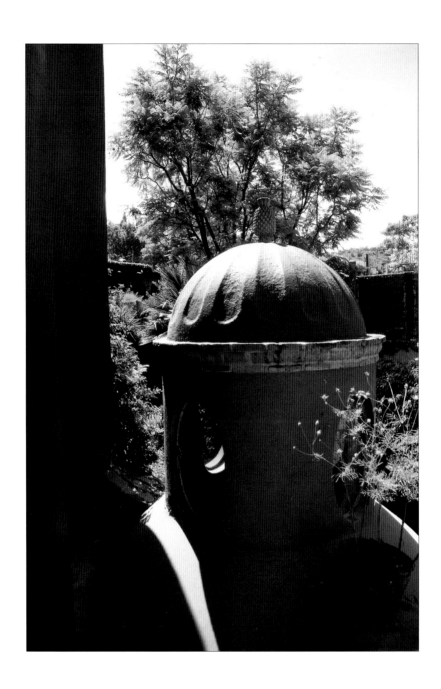

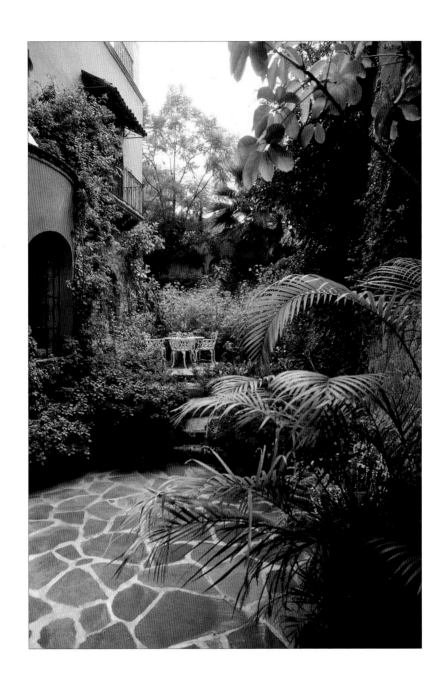

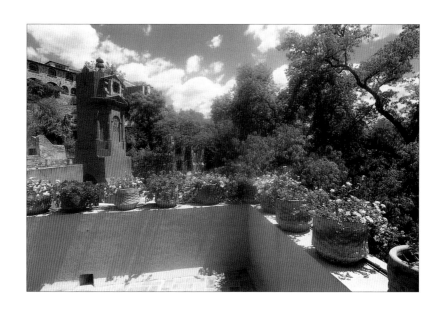

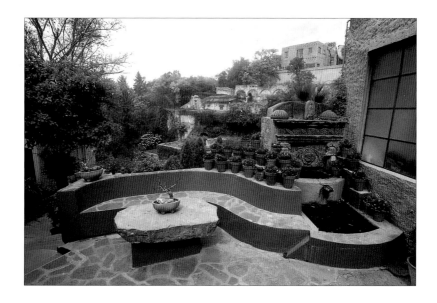

CHORRO 39 // SANTO DOMINGO 38

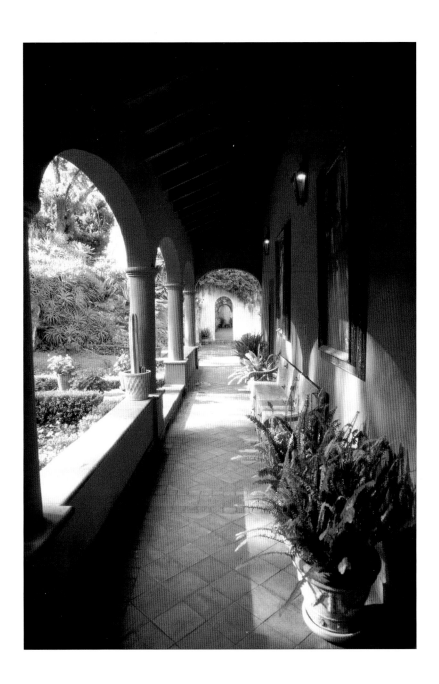

SANTA ELENA 2

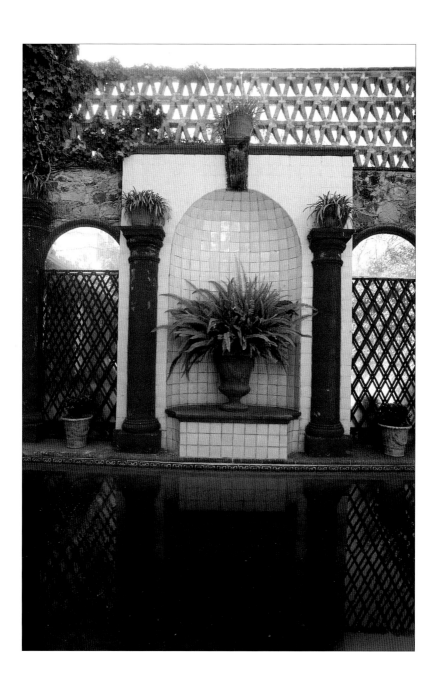

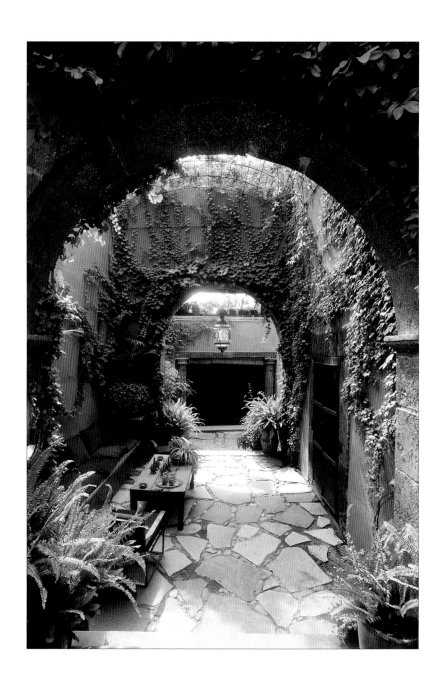

PILA SECA II

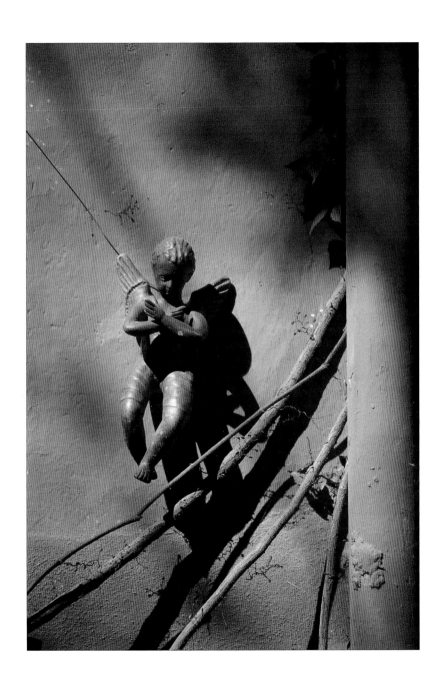

PILA SECA II

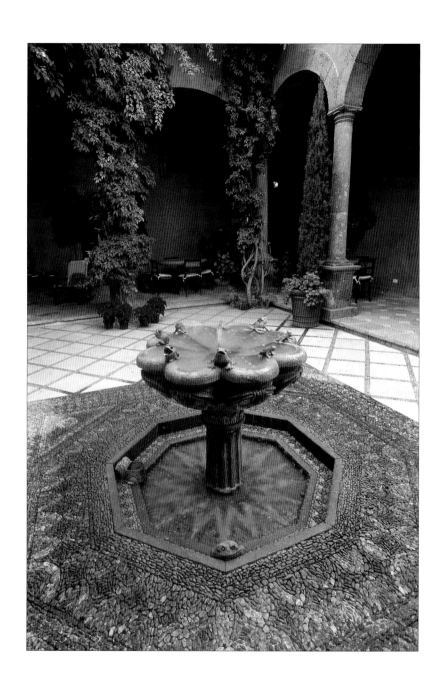

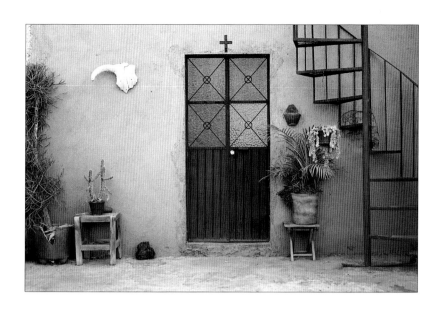

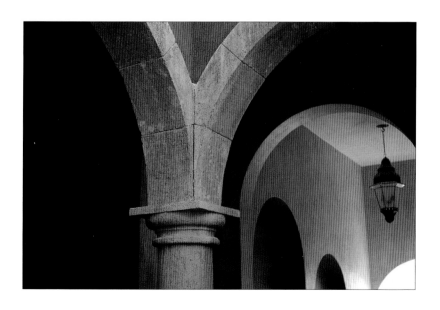

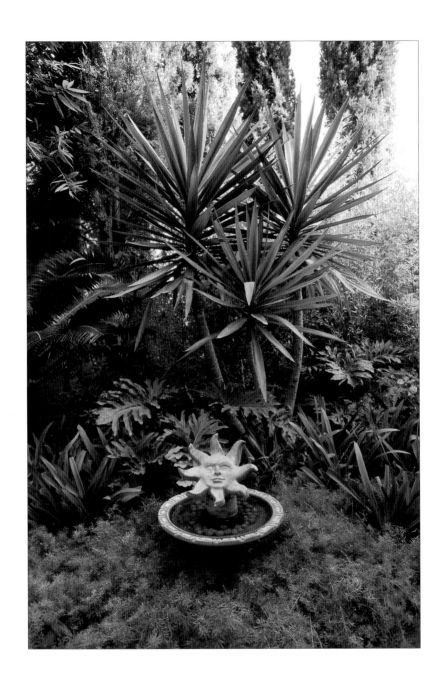

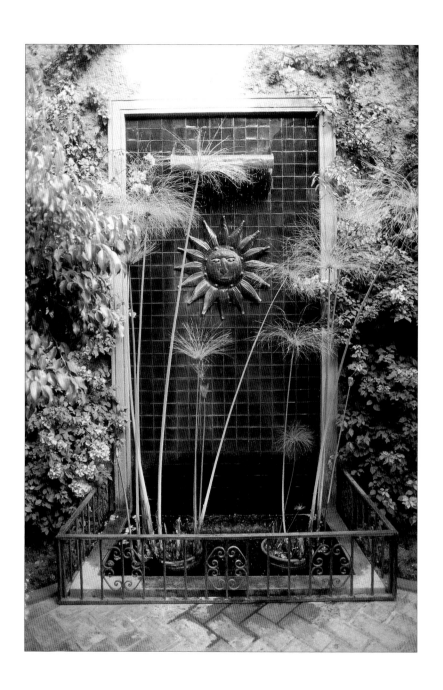

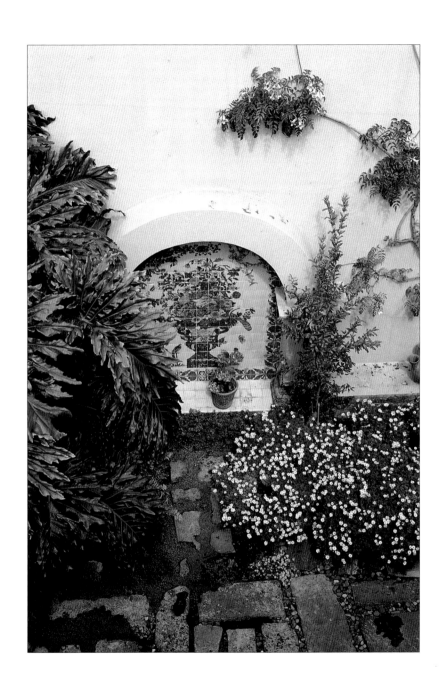

CALLEJÓN BLANCO II

CALLEJÓN BLANCO II

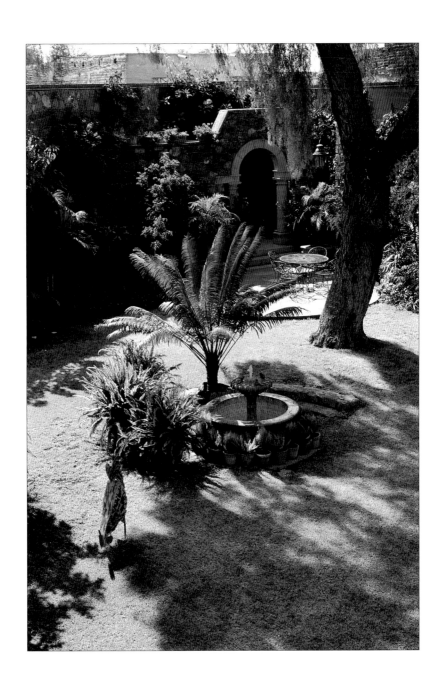

CALLEJÓN BLANCO II

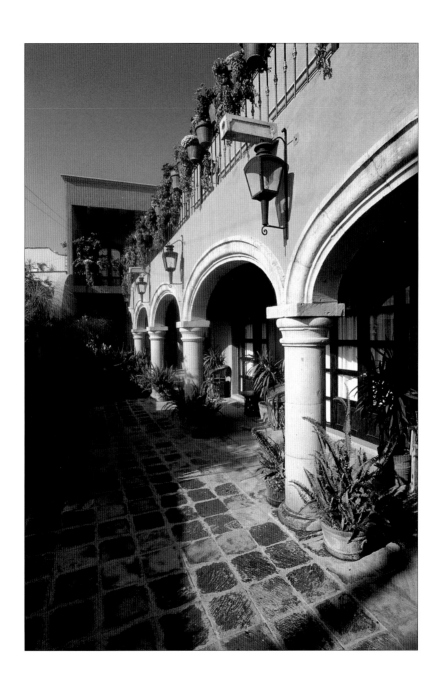

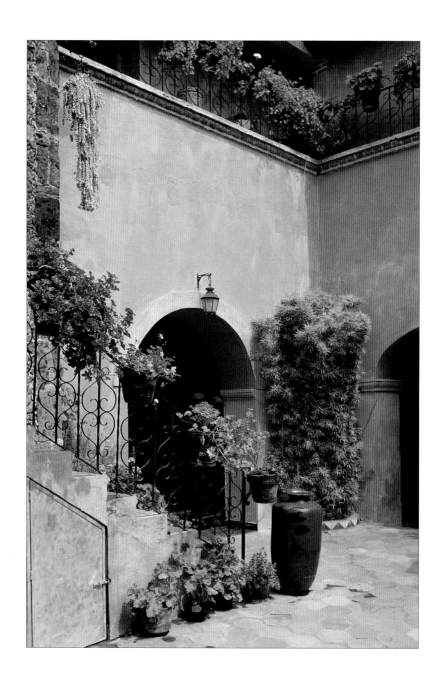

PILA SECA I

54

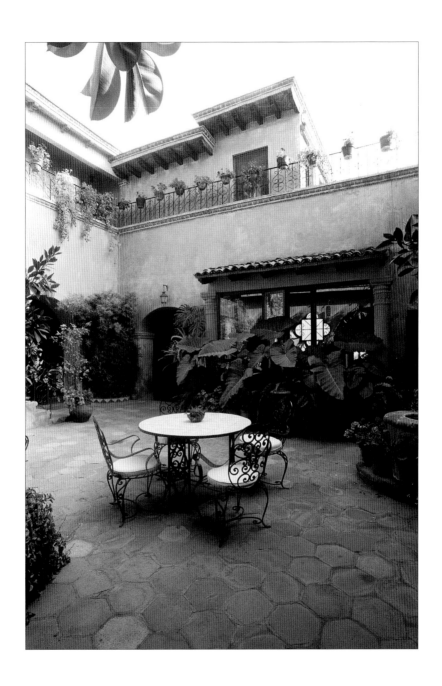

PILA SECA I

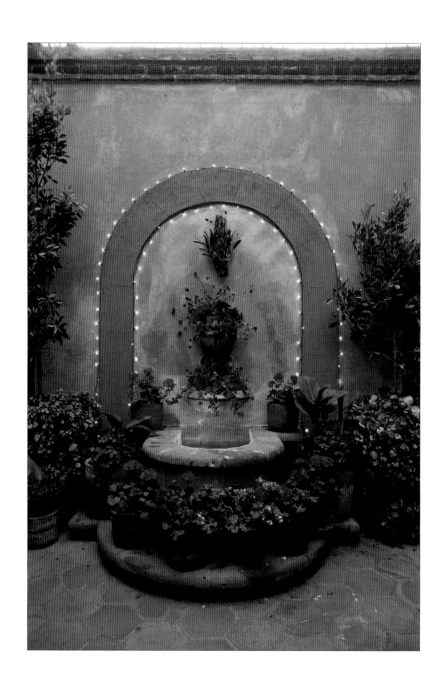

PILA SECA 10

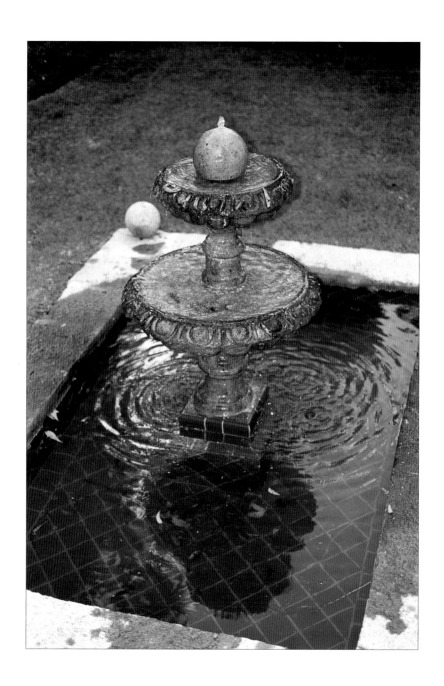

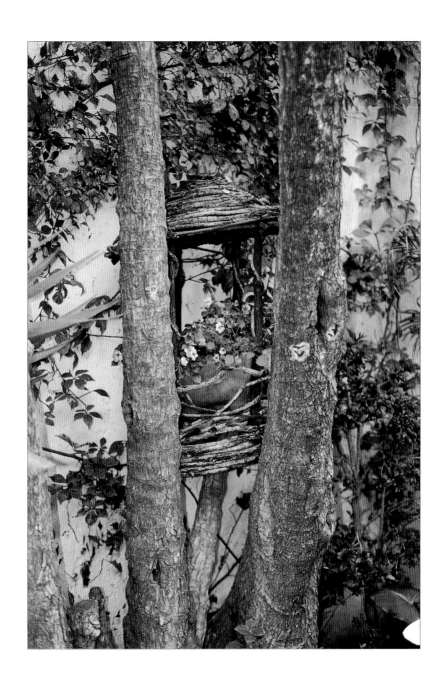

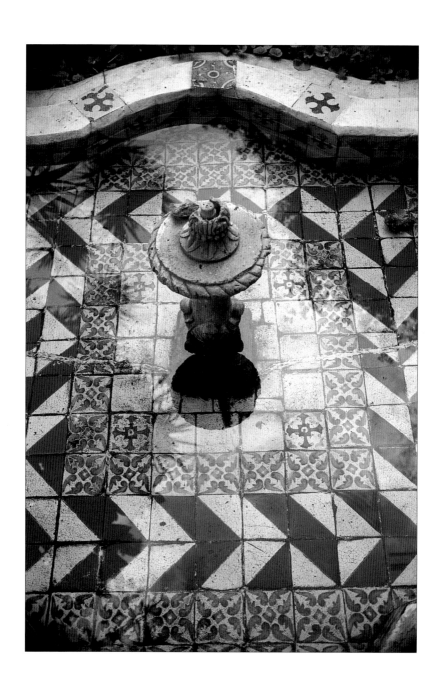

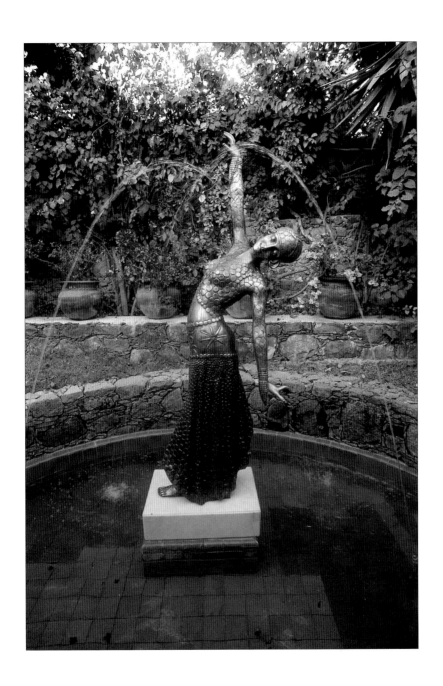

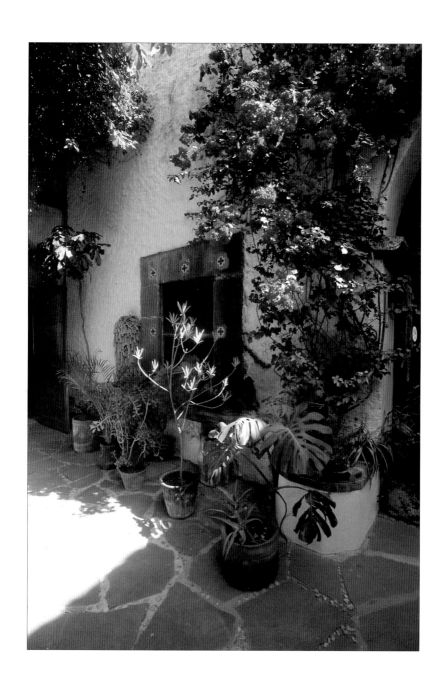

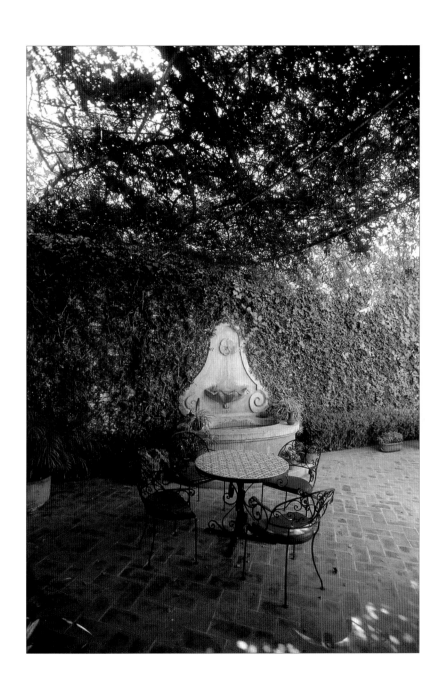

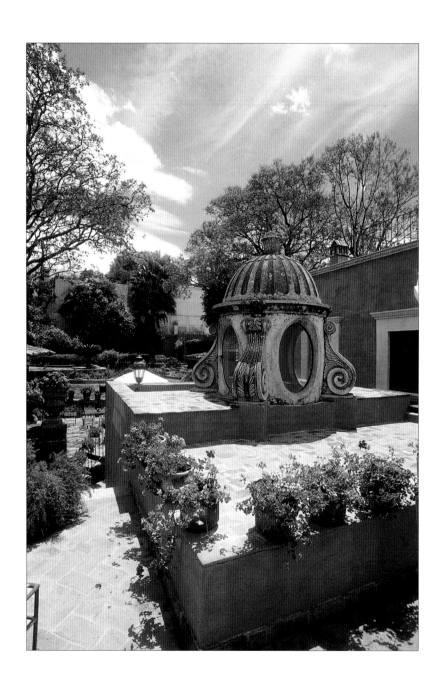

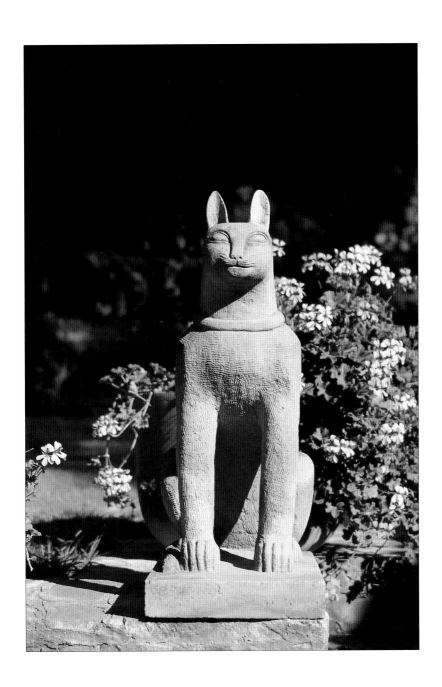

ALDAMA 38

HOSPICIO 44

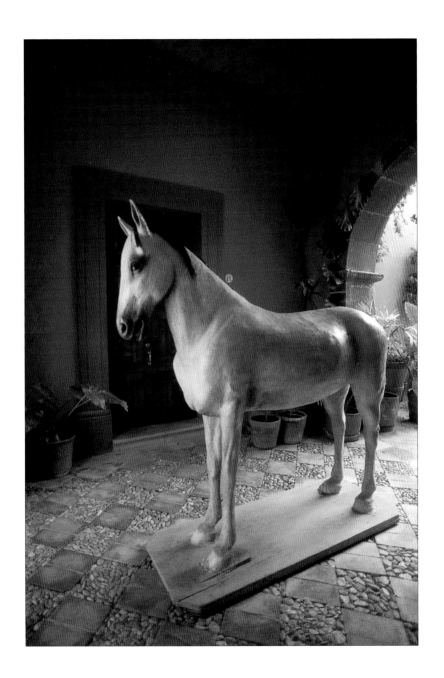

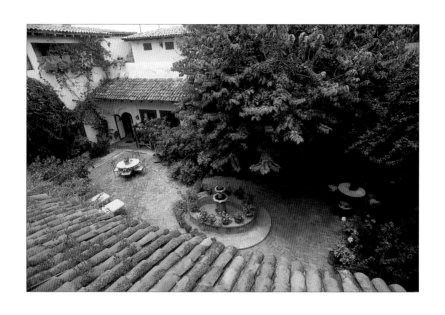

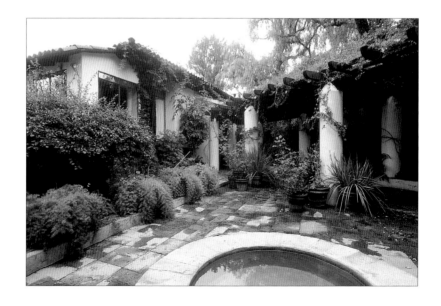

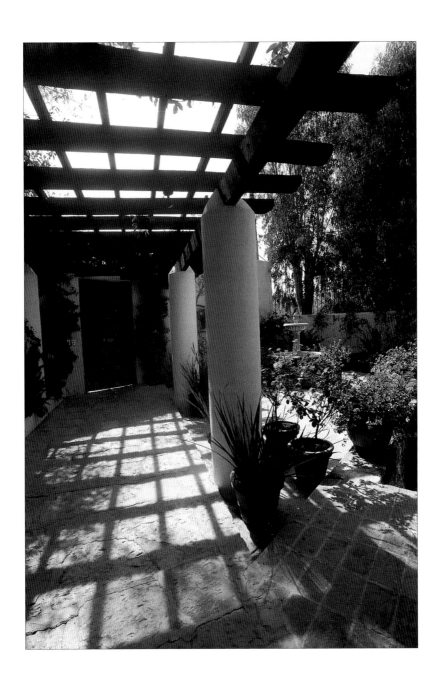

FUENTES II

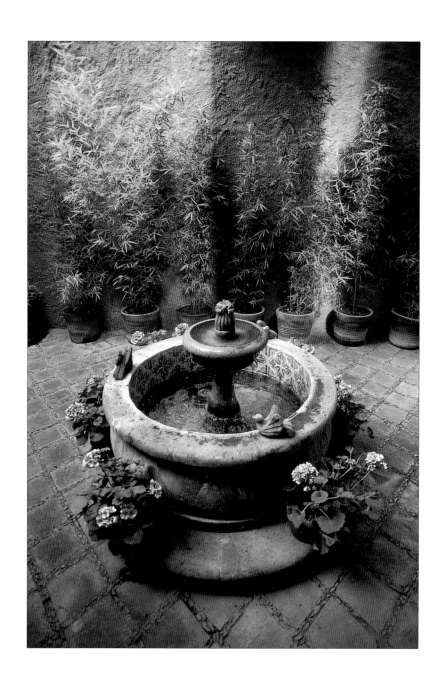

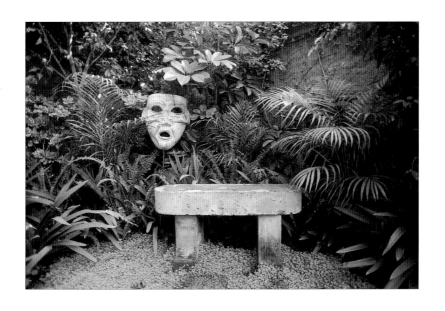

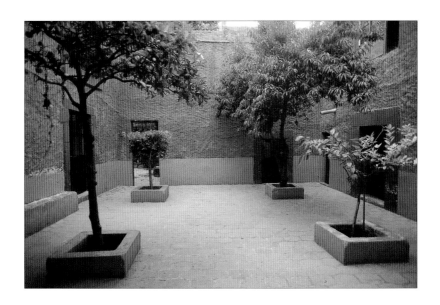

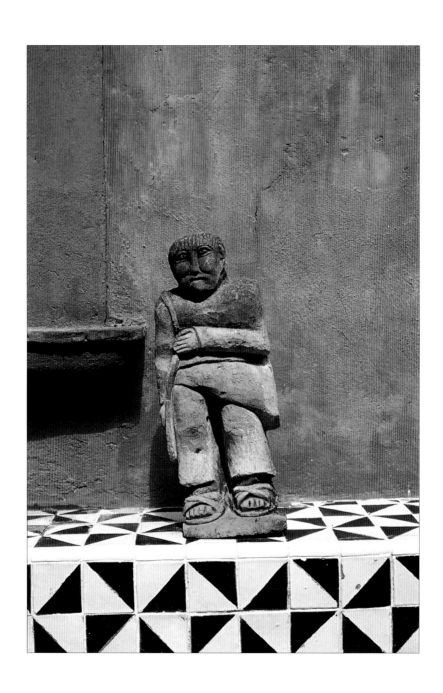

BAJADA DE LA GARITA 4

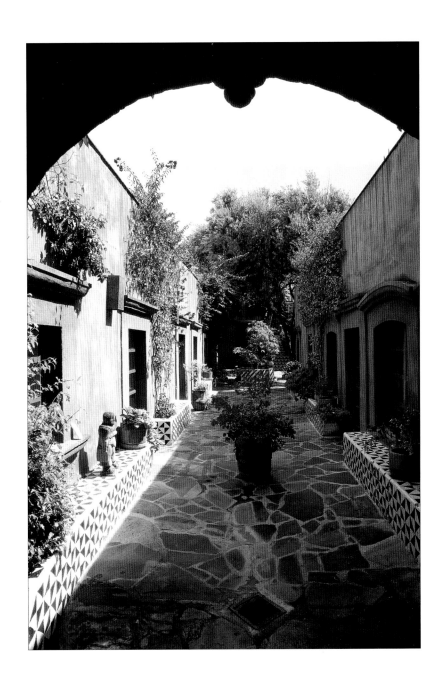

BAJADA DE LA GARITA 4

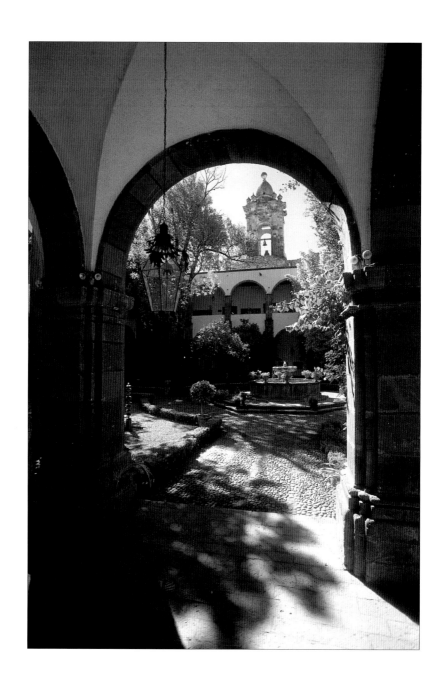

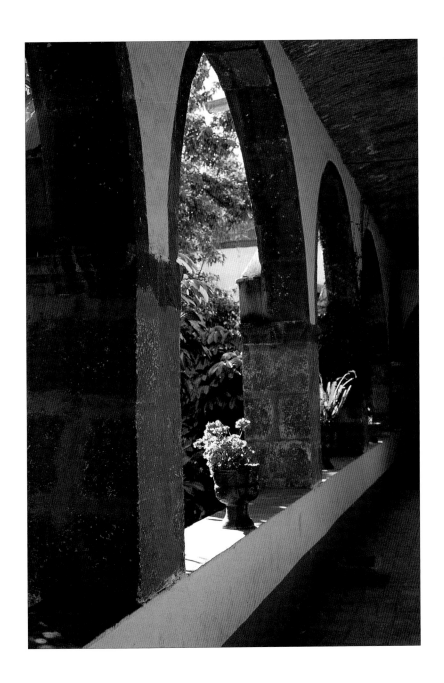

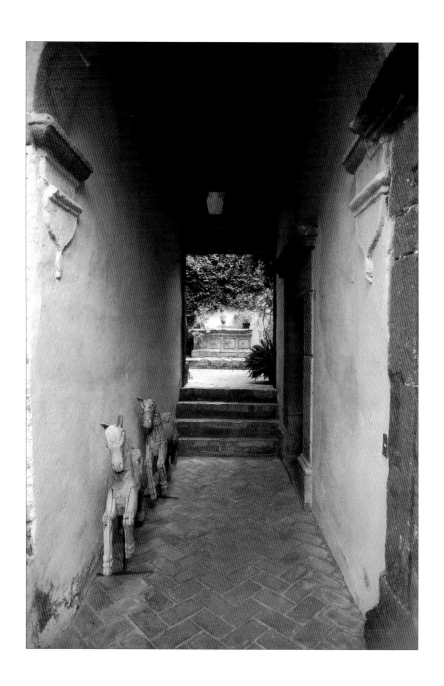

MESONES 4

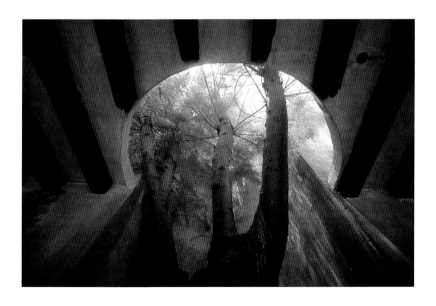

MESONES 4 // BAEZA 5

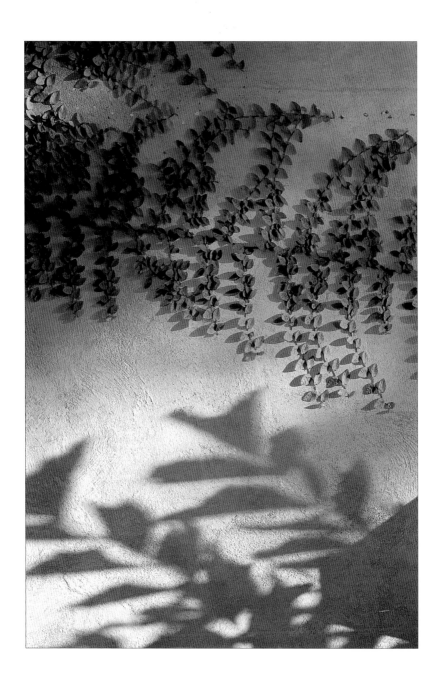

BAEZA 5

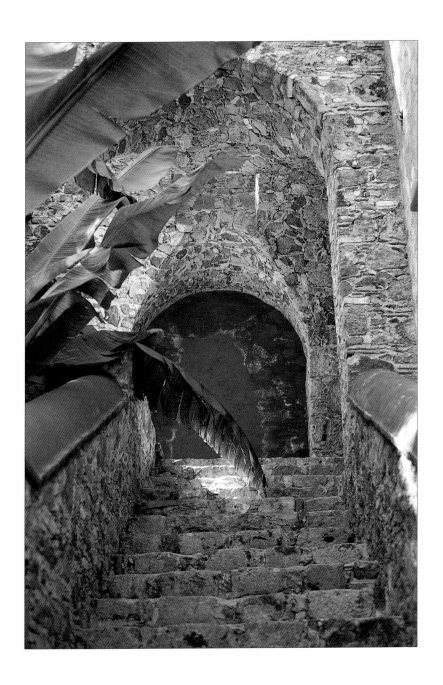

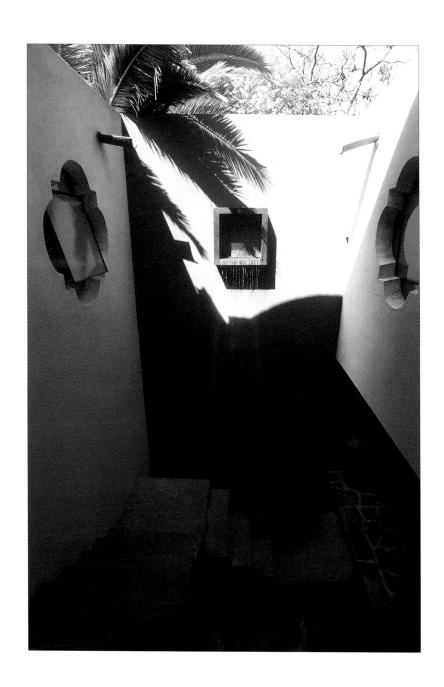

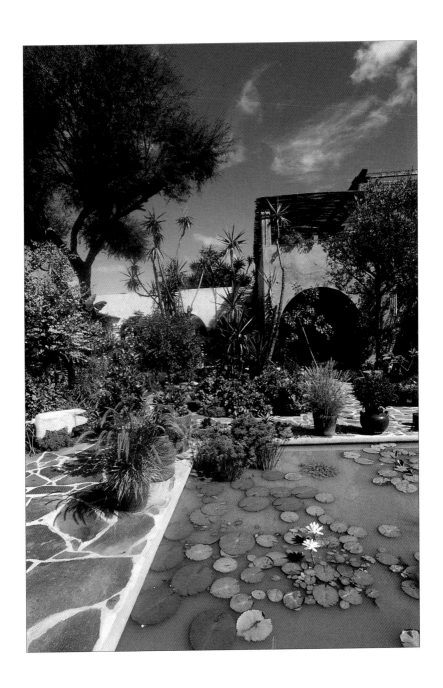

CERRADA DE PILA SECA I

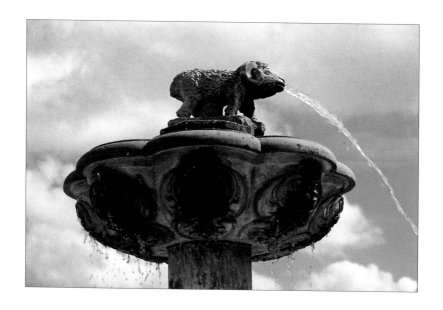

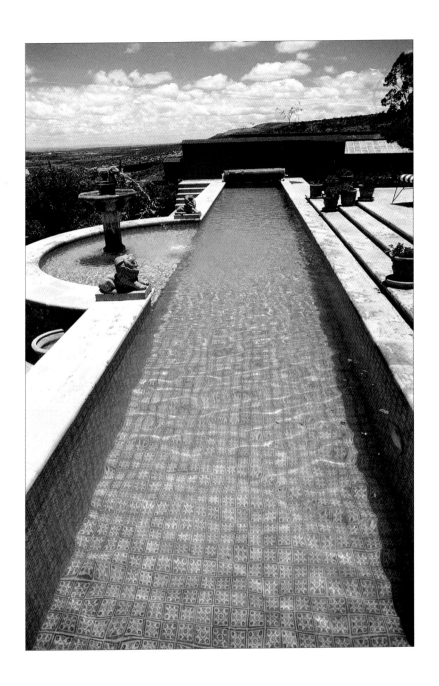

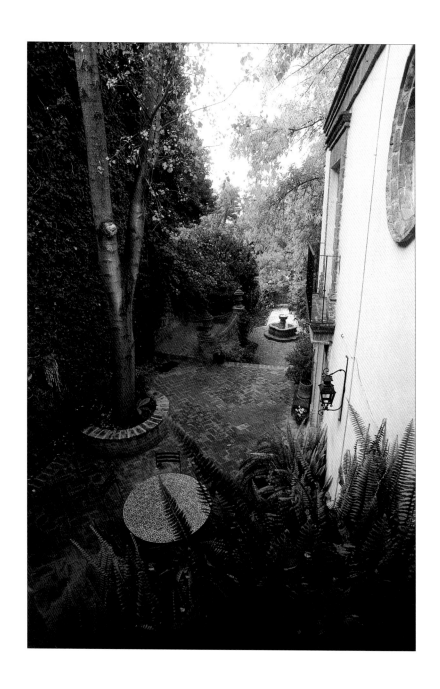

CHORRO 33

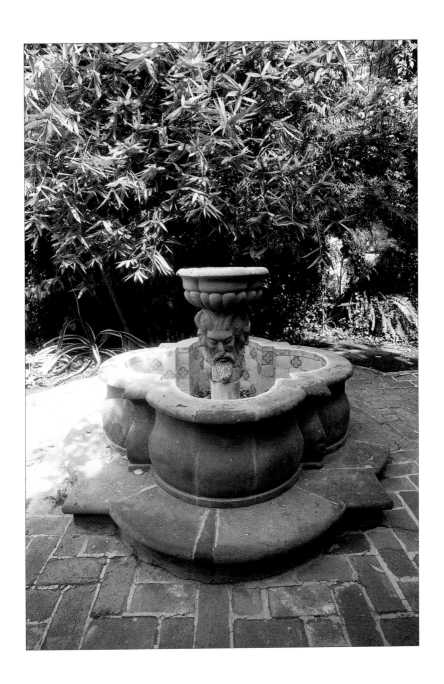

CHORRO 33

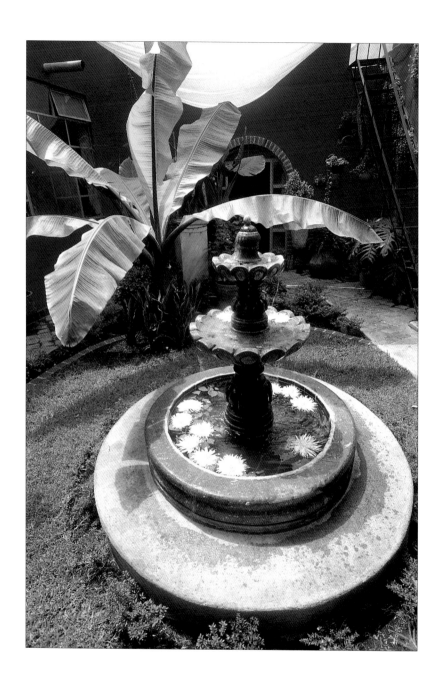

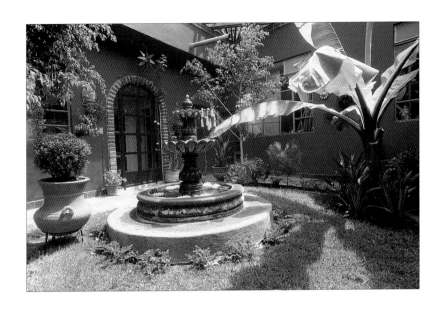

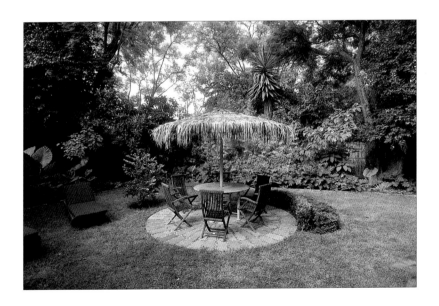

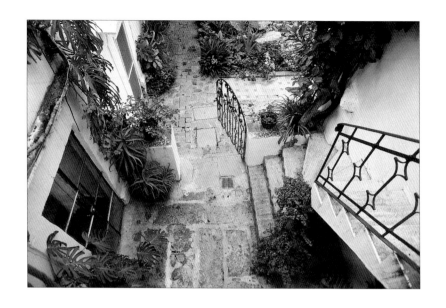

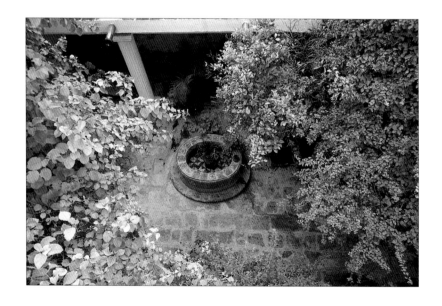

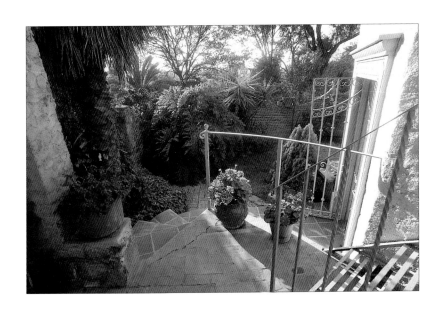

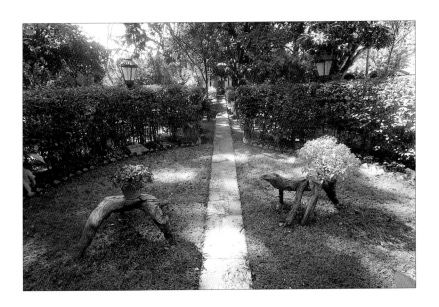

ALDAMA 43 // TENERÍAS 45

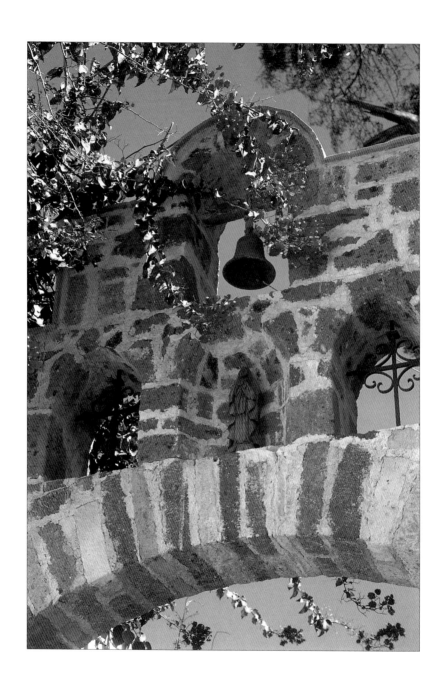

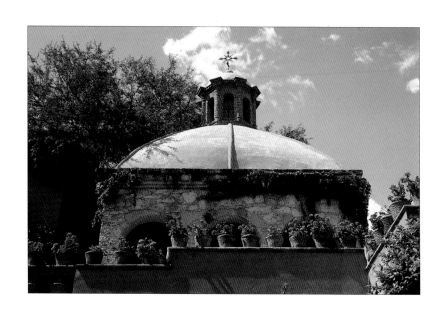

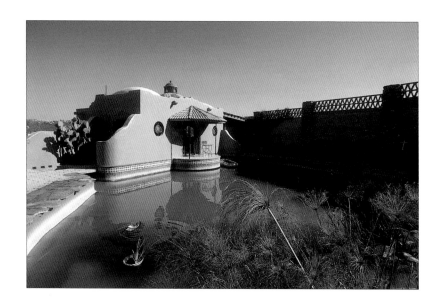

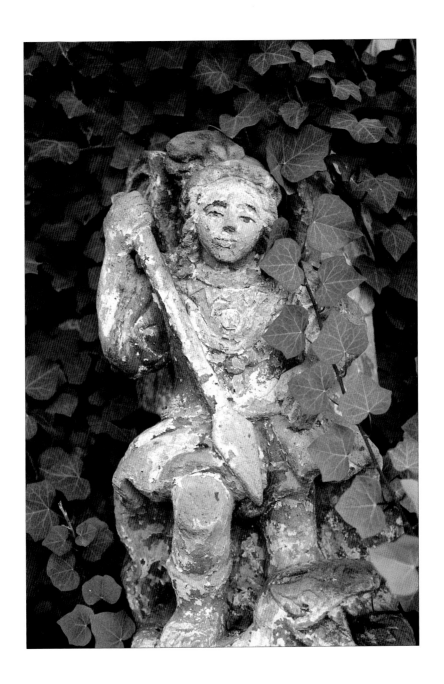

ACKNOWLEDGMENTS

*Getting my camera and me
behind the doors of San Miguel
was no simple enterprise.
I am indebted to many friends,
neighbors, and homeowners
for their suggestions, ideas,
and generosity. My thanks!*

Tom and Mary Ambrose
Russ and Marion Archibald
Elliot and Rose Aronin
Evita Avery
Brooks Baekeland
John D. Block
Charles and Susan Bloom
Daniel Borris
Hal and Eden Box
Tom Brightman
Marsha Bland Brown
Jack and Loreta Castle
Evelyn Chisolm
Nanci Closson
John and Barbara Clum
Tony Cohan
William and Mary Cole

Tito and Nancy Cordelli
Irene Corey
Toller Cranston
David and Caren Cross
Alice Dale
Margarette Dawit
Marcia Dworkin
Nancy Dusseau
Clyde Ellis
Karen Gadbois
Nancy Gallagher
Bud and Ivy Geiger
Toni Gerez
Gerry Gill
Terry and Kathy Graves
Bud and Allison Gubelman
Jennifer Hamilton
Warren and Tuli Hardy
Bruce and Page Hayes
Max Jackson
Terry and Leslie Von Jaeger
Doris James
Marlene Johansing
Aileen and Frank Jones
Keith Keller
Betty Kempe

Shaaron Kent
Martin Keogh
Fred and Bobbie Kleinman
Don and Pam Knoles
Rita Krug
Diane Kushnner
Anne Ladue
Dick Leet and Kay Lahey
Billy and Diane Largman
Bill and Heidi LeVasseur
Dana Little and Morgan Gilbert
Elvia López de Beora
Charles and Mary Marsh
Valerie Mejer
Sharon Milligan
Robin and Becky Millward
Horace and Natalie Mooring
Peter Mudge
Bart and Connie Mullis
Bill Munro
Eduardo and Micaela Obregón
John Oppenheimer
Joan Palmer
Sue Paris
Bill and Barbara Porter
Louis and Alejandra Racine

Mary Rapp
Jack and Therese Kutt Reinhart
Sally Richman
Daniel Scher
Sidell Schooler
Barry Shapiro
Suzi Shelly
Lisa Simms
Alice and Polly Stark
Forrest and Joan Stevens
Robert Stevens and César Cahue
Mort and Joyce Stith
Masako Takahashi
Margaret Ann Taylor
Peggy Taylor
Billie Temple
Christine Tobias
Joseph Turner
Héctor Ulloa
Kees Van de Graaff and
 Terence Clarkson
Bernard and Worth Van Zandt
Dorothy Vidargas
Ricardo and Joan Vidargas
Cassandra Webb
Cindy Zavala